Flow and Art

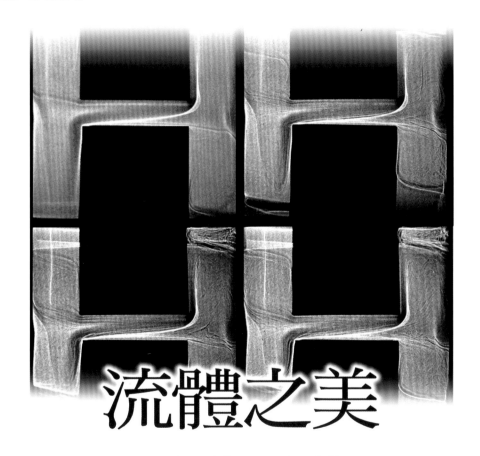

流體之美

王立文　曾華　康明方　合著

王立文教授流體藝術工作室

元智大學人文通識倫理辦公室

教育部邁向頂尖大學計畫

王立文 教授簡歷

學歷： 1983 美國凱斯西儲機械工程博士

現任：元智大學通識教育中心主任
　　　元智大學機械工程學系教授
　　　中華民國通識教育學會理事
　　　佛學與科學期刊主編

經歷： 2003 元智大學副校長
　　　1999 元智大學教務長
　　　1987 美國 NASA 路易士研究中心副研究員
　　　1983 成功大學航空太空工程學系副教授

Abridged biography

Credential: Doctoral in Mechanical Engineering, 1983, Case Western Reserve University, USA.

Current positions: Director, General Education Center, Yuan Ze University
Professor, Dept of Mechanical Engineering, Yuan Ze University
Executive director, General Education Association of the ROC
Editor in chief, Journal of Buddhism and Science

Exposure: 2003 – Vice President, Yuan Ze University
1999 – Dean of Academic Affairs, Yuan Ze University
1987 – Research Associate, U.S. NASA Loius Research Center
1983 – Associate Professor, Department of Aviation and Aerospace Engineering, National Cheng Kung University

序

　　看著白雲悠悠地飄浮於藍天，看著夕陽映照著晚霞，諸位可曾感到這流體藝術的存在。在下雨天，在窗邊看著雨滴的互動，融合似直線又不似直線地向下流；駐足小溪旁，看著溪水繞過青石緩緩流著，有一種美不太容易表達，這美是外在還是內在呢？抑或是既有外在亦含內在？

　　多年來我帶著許多研究生埋首於熱質對流實驗室，挖掘流體力學的奧秘，有許多流體圖片訴說著物理世界的規律，多篇科學論文因之而發表在國際期刊與國內外的會議。偶而，我在美術館或書店的藝術書籍看到一些抽象名畫，會覺得和我們的流體相片相去不遠，因此我開始對實驗圖片有了一種不受制約的看法，流體的科技圖片在我手中原是中規中矩的以科學態度來觀察，現在有時我會把它倒著或轉九十度來看，別有一番『韻』味在心頭，這一些圖片不再只帶給我科學的信息，亦帶給我藝術的靈感，在制約中，我看到規律的科學世界，放下制約，我溶入到藝術世界裡。

　　在王德育教授擔任元智藝管所所長期間，我的流體藝術參與了兩次展出，還做過一次公開的演講，流體運動在我心中不再只是吃飯傢伙之專業智能，它也成為我溶入藝術大千世界的一股動力、一扇門。因有了流體藝術這塊寶，我開始對藝術開了竅，有很長的一段時間我對美簡直是一無所感，凡事求真，勤讀理則學、數學與物理，嚴謹地做科學實驗，那時我是『方』的，有稜有角，堅持真理，在別人眼中我是個求真的鬥士。當我涉足藝術甚至宗教，稜角沒了，我不再是方的，美亦能令我心醉，無言清淨的琉璃世界更是我所嚮往。

　　今年曾華同學從重慶來協助我完成一個小夢，曾華本想到元智找個藝術老師指導他的雕塑，不巧王德育所長休假不在台。在一個機緣下曾華看到了熱質對流實驗室的圖片，愛不釋手，興起為這些流場模型圖片做雕塑的念頭，這些科學圖片原是在暗房裡用雷射光投

Preface

When seeing the clouds freely flowing in the blue skies, when watching the rays emitted by the setting sun, have you ever felt the existence of flow art? On rainy days, standing by the window and watching the raindrops merge and trickle down integrating in a linear and non-linear manner; watching the creek water flow slowly bypassing the green stock, there is a form of indescribable beauty. Is the aesthetics extrinsic or intrinsic, or does it encompass both?

Over the years, I have spearheaded many postgraduate students to work on heat mass conduction laboratories, explore the mystique of flow dynamics, where many flow depictions tell the rhythm of the domain of physics, and many scientific theses have been debuted in international journals and at local and foreign conferences as a result. By chance, as I invariably feel that some of the famous abstract paintings in art books I see at bookshops or in museums are not very different from our flow pictures, I now occasionally turn the pictures up-side-down or rotate 90 degrees to take in the special flare, reckoning some of the photos revealed to me more than just scientific information but also an inspiration in art. While it is through the rigid discipline, I see the realm of disciplined science, yet once abandoning the rigid discipline, I find myself immersed in the realm of art.

During the time when Professor Wang De-yu spearheaded the Yuan Ze Graduate School of Visual Arts Management as director, as my flow art is staged in two exhibitions, and I giving a public lecture, the science flow movement has become more than a professional knowledge that I rely on as a career, but also a force and a door that brings me to immerse in the realm of art. It is through the gem of flow art that I begin to aspire to art, against how I used to be clueless to the aesthetics but only worked hard on the science of mathematics and physics, stringently tackled lab work, when I was square-faced, rigid, perseverant that others see me as a truth fighter. When after exposed to art or even religion, I have not only lost my rigidity, but aesthetics now keeps me hypnotized, and the silent realm of nirvana is something I long for.

This year with student Tseng Hwa returning from Chongqing to help me complete a small dream of mine, Tseng Hwa was initially looking for a art teacher at Yuan Ze to tutor his sculpting, but unfortunately director Wang De-yu was on leave and not in Taiwan. In a chance encounter, Tseng Hwa saw heat mass conduction lab imagery and was gravitated by them who began to have the idea of sculpting the flow field model imagery. Although these scientific photos were once derived from laser projection in darkroom, through Tseng Hwa's ingenious hands, Tseng Hwa not only brought 2-D computer imagery to a 3-D form, but also projected the virtual 3-D flow art onto campus and MRT station lobbies, making it an ingenious pioneer move in how he brought the darkroom's red-flow projection models to life in broad daylight.

射才能得到的，經過曾華的巧手，在電腦裡曾華不但讓平面圖立體化，更將這些立體的流體藝術虛擬地放置於校園及捷運站大廳中，原生於暗房的紅色流場模型居然有機會能展露於光天化日之下，真是巧奪天工的創舉。

另外康明方同學是我的碩士生，他是從熱質對流實驗室培養出來的工學碩士，在他準備出國攻讀博士這段期間，我請他做藝術助理，將以往研究生的科學圖片挑選一些，重以藝術眼光來看它們，並稍微用電腦軟體著色，亦頗有可觀之處。明方不但是從我這學習流體力學實驗，他亦選讀我在通識中心開設的佛典選讀，他研讀過金剛經與六祖壇經，亦上過王德育所長之藝術賞析的課。明方不只是個科技碩士，人文藝術素養成長亦頗令人欣慰，一個做老師，最高興的就是看到學生能有好的發展，尤其碰到能夠內外兼修的好學生。

這本書能出版，除了有曾華及康明方兩位同學的努力及創意之外，我亦必須歸功於我所有的研究生，有畢業於成功大學的：孫大正、莊柏青、鄭敦仁、陳燦桐、陳人傑；有畢業於元智大學的：李連財、魏仲義、路志強、呂俊嘉、賴順達、李慶中、侯光煦、盧明初、呂逸耕、鄧榮峰、徐嘉甫、王伯仁、林政宏、徐俊祥、粘慶忠、楊宗達、陳國誌、廖文賢、馮志成、蔡秀清、孫中剛、王士榮、鄭偉駿、周熙慧、龔育諄、莊崇文、林冠宏、康明方、蘇祺同、宋思賢、許耿豪、林君翰、歐陽藍灝、廖彧偉、許芳晨、郭進倫、戴延南、吳春淵，沒有他們當年在科學實驗室中的努力耕耘，這些美而有韻味的流體藝術就無緣呈現給讀者們了。最後要感謝教育部邁向頂尖大學計劃及元智大學人文通識倫理辦公室的支援，這本『流體之美』方能展現於世人之前。

元智大學通識教育中心主任

王立文　謹識
二〇〇七年七月

Moreover, with student Kang Ming-fang, a master student of mine, who finds his engineering master centering on the lab work of heat mass conduction, in the period when he prepares to study for a doctoral abroad, I have asked him to be artistic assistant to sort out some of the previous postgraduate students' scientific graphics by reexamining them with an artistic eye, and tough them up with color using computer software, which he has done a remarkable wonder. More than studying under me on study flow dynamic experimentation, but also an elective student in the elective Buddhist sutra study I lecture at the General Education Center, Ming-fang has more than perused the Diamond Sutra and the Platform Sutra of the Sixth Patriarch, but has also taken director Wang De-yu's art appreciation course. With Ming-fang being more than a master in engineering, but also with impressive exposure in humanity and arts, it is the elation of being a teacher to witness the students grow positively, especially in spearheading fine ones focusing both extrinsic and intrinsic disciplines.

Attributing not only to the efforts and creativity of two students of Tseng Hwa and Kang Ming-fang, I also own the publishing of this book to all my postgraduate students, with some graduated from National Cheng Kung University, namely Sun Da-cheng, Tsuang Poh-ching, Cheng Tun-jen, Chen Tsan-tong, Chen Jeh-jeh; some graduated from Yuan Ze University, namely Lee Chien-tsai, Wei Chung-yi, Lu Zhe-chiang, Lu Jun-jia, Lai Shun-dah, Lee Ching-chung, Hou Kuang-shi, Lu Ming-tsu, Lu Yi-geng, Deng Rong-fong, Hsu Jia-fu, Wang Poh-jen, Lin Cheng-hong, Hsu Jun-shiang, Nien Ching-chung, Yang Zhong-dah, Chen Kuo Zhe, Liao Wen-shien, Fong Zhe-cheng, Tsai Shu-ching, Sung Chung-gang, Wang Shih-rong, Cheng Wei-jun, Chou Shih-lun, Gong Yu-tusen, Tsuang Zhong-wen, Lin Guan-hong, Kang Ming-fang, Shu Geng-tong, Sung Shih-shien, Hsu Geng-hao, Lin Jun-han, Ouyang Lan-ying, Liao Ho-wei, Hsu Fang-cheng, Kuo Jin-lun, Dai Yen-nan, Wu Tsuen-zhou, for without their painstaking efforts at the science labs then, it would not be possible that these aesthetic and sensual flow art are presented to the readers. Last but not the least, I am grateful for the generous support of the Ministry of Education's University Epitomizing Program and Yuan Ze University General Knowledge & Humanity Office that made it possible for presenting the "Flow and Art" for all to appreciate and enjoy.

Sincerely yours,

Director, General Education Center, Yuan Ze University

Wang Lin-wen

July 2007

心靈的原生風景

　　您知道白雲蒼狗的浮生世界有哪些美麗的風光嗎？朝暉夕嚥、驚濤川流、迴瀾飛瀑、斷崖蒼嶺……，那些來自大自然的美，千奇百怪，人文世界所創造不了的，科學領域所無法解析的，無以名之，我只能稱它為「原生風景」。

　　《六祖壇經》說：「世界虛空，能含萬物色像。日月星宿、山河大地、泉源谿澗、草木叢林、惡人善人、惡法善法、天堂地獄、一切大海、須彌諸山，總在空中。」原來這就是「原生風景」！「原生風景」來自虛空，虛空存在我們的心靈，《六祖壇經》說：「自性能含萬法是大，萬法在諸人性中。」我走過許多世界的人文古蹟，終於在元智大學通識中心王立文教授的流體力學中發現真正的「原生風景」。

　　1988 年，元智大學剛剛創立，我帶著尋幽訪勝的心情踏上草創的校園。站在一館的樓台前游目聘望，四野還是一片漠漠水田飛白鷺的鄉間景象。我的責任是國文教師，外加人文活動推手。在這兒，我認識當時的機械系主任，後來歷任學務長、教務長、副校長兼通識中心主任的王立文教授。初識王教授，我所面對的是一位思惟科學化、行事步驟謹嚴，開口帶著幾句洋文的工學學者。我忽然驚覺自己如在慈禧太后的坤寧宮中睡夢初醒的宮娥或嬪妃，一個半生大多用古文思考的中文系學究，怎麼就如此錯謬地面對這一片不僅以科學起家且教師語言多半中英文夾雜的校園。原來洋人不僅已經輸入洋槍大砲，世界早已經是國際化、網際網路化了。

　　1989 年，在王教授的引領下，我們開始在元智大學成立師生共同研讀經典的社團。從《靜思語》到《金剛經》到《六祖壇經》；從科學的「熵」到「混沌原理」到「心靈網路」；從通識教育、全人思想到倫理與科技。在王教授的實驗室與辦公室中，門雖設而常開，學文學的、學哲學的、學藝術的、學管理的、學科技的，不同族群、不同知識背景的教授與學生不斷地穿梭進出。人文與科技不再扞格難通，一處超人文與科技的原生地帶就在這裡產生了。

The Soul of the Unspoiled Landscape

Are you aware what enchanting aesthetics that exists in the fleeting, shifting mortal world?　Of sunrise and sunset, streams and waves, cascading waterfalls, tall summits and harsh cliffs, the wondrous beauty of nature cannot be created by human world, nor discerned by science, and for the lack of a better name, I can only refer to it as the "Unspoiled landscape".

As stated in the Platform Sutra of the Sixth Patriarch, "The realm of space encompasses all things of varied shapes.　The sun and moon and stars, rivers and land, streams, vegetation and forests, people of good and bad, deeds of good and bad, heaven and hell, all seas, and all mountains have all existed within universal emptiness." This is what the "Unspoiled landscape" is all about, for the "Unspoiled landscape" exists in universal emptiness, and the universal emptiness rests in the soul of mankind. As stated in the Platform Sutra of the Sixth Patriarch, "The original nature can embrace all things, this is greatness. All dharmas are within our nature."　I have traversed many human relics around the world, and have finally discovered the authentic "Unspoiled landscape" in flow dynamics through Professor Wang Lin-Wen of Yuan Ze University General Education Center.

In 1988 when Yuan Ze University was first founded, I found myself at the campus with a curious mind.　Looking around standing in front of the building of Hall one, all around was still a pastoral rural scene of immense rice fields and passing egrets.　My responsibility had been a Mandarin teacher, and an instigator in humanity activities.　It was in here, I gained the acquaintance of Professor Wang Lin-Wen, then chairman of school of mechanical engineering, who progressed into dean of academic affiars, dean of student affairs, vice president and director of the general education center.　When meeting Professor Wang initially, I saw an engineering scholar with scientific thoughts, stringent demeanors, who spoke intermixing with English phrases.　I felt like a chamber maid or a concubine that came to a rude awakening at Empress Tzu Shi's Kuen Ning Palace wondering how a Mandarin-major scholar spending a good part of her life thinking in classic literature would accidentally stumble onto a campus founded by scientists with whose language interlaced with Mandarin and English.　So the foreigners have brought in guns and munitions, and the world has become globalized and linked by the World Wide Web Internet.

In 1989, as spearheaded by Professor Wang, we began to form a faulty/student classic reading society at Yuan Ze University, and the society reading encompassed those from the JingSi Aphorism by Master Cheng Yen, the Diamond Sutra to the Platform Sutra of the Sixth Patriarch; from the scientific chaos, the chaotic theory to the network

　　古代希臘的科學家和哲學家往往集於一身，近代由於科學的高度專門化，各部門的科學間，已有「隔行如隔山」的情形，科學與人文學則更成為兩個世界。約在三十年前，英國的史諾氏（C.P Snow，原習物理學，後成為名作家），指出近代科學和人文學成為深隔鴻溝的兩個文明；科學家和人文學者缺乏共同的知識、語言、觀點及相互瞭解的志趣，對國家社會的和諧，個人生命的享受，都有嚴重可憂的影響的。然而這個憂慮顯然是多餘的，在王教授引領的世界裡，我們發現了原生風景。

　　王教授帶領過幾十位研究生，將實驗室中一張張流體實驗的照片轉化為人工所不可及、藝術所歎為觀止的作品。有的如微風輕拂的薄紗起舞、有的如陽光撒落大地、有的帶來滄茫的原野氣息、有的如新葉抽芽吐出鮮嫩。總之，這些作品叫人見著只能驚訝無言，因為它包孕著世間與出世間的大美，引發著人的心靈靈思，它肯定是會令未來藝術界同聲驚嘆的創舉。如今，它即將出版問世，我帶著無以名之的心情，再一次稱嘆：「啊！原生風景」。

<div style="text-align:right">

台大中文系教授

蕭麗華

於板橋玉函樓　二○○七年七月

</div>

of spirituality; from the general education, holistic thinking to morality and technology. Through the open door to Professor Wang's lab and office, a wide range of professors and students with literature, philosophy, art, management, science backgrounds and with varied creed and knowledge backgrounds traversed in and out. With humanity and technology made accessible, an unspoiled haven transcending humanity and technology has been born.

Ancient Greek scientists also tend to be philosophers notwithstanding, the highly specialized science in modern times has led to the phenomenon of a great divide in specialized occupational knowledge, which further set apart science and humanity into two distinct realms. Roughly three decades ago, the British thinker C.P. Snow, once a physicist and later a renowned writer, has said that modern science and humanity are increasingly become two deeply divided civilizations; scientists and humanity scholars often lack common knowledge, language, viewpoints or interest in bridging mutual understanding, which in turn creates a profound, yet worrying impact in the peace and harmony of the state and society, the enjoyment of individual existence. Yet with such concern being obviously redundant, for in the realm spearheaded by Professor Wang, we have found the unspoiled landscape.

Professor Wang has successfully spearheaded tens of postgraduate students to transformer one after another of flow mass lab experiment photographs into works unachievable by human wits and superlative in an artistic sense. Some bespeak of flowing chiffon dancing to the light breeze, some resemble the sun caressing earth, some project an air of rustic ambiance, and others conjure a tenderness of budding new leaves. As a whole, the works beckon for sheer amazement, for how they encompass the greater earthly and surreal aesthetics that inspire soulful aspirations, making them no doubt a pioneering move among the future artists. At a time when the book will soon be debuted, I am aspired by an indescribable perception to marvel once more, "How swell! The unspoiled landscape".

Professor, Department of Chinese Linguistics, National Taiwan University

Shiao Li-hwa

At Yu Han Tower in Panchiao July 2007

天韻渾成

　　王立文老師以其靈慧雙眼，透視自己流體實驗深具藝術特質之美，是早在十多年前的事。彼時校內一片人文沙漠，少人能知藝術，他便尋來問我對其流體圖像的看法，而我以對藝術的單純直覺，發現那種由於實驗結果而產生的流體之美，直是另類抽象藝術的表現。在人工條件之下所呈現出來的流體紋理，如此千變萬幻，又如此單純自然，充滿了線條的力感、動感與美感，讓我驚豔連連。不但如此，我又在一張張黑白的波紋裡，看見了一幅幅意韻深遠的動人情調，有小我生命的低迴，有大我自然的歌詠，那是人類繪畫所無法創造出來的法性之美。當時正擬出版我的第一本詩集，於是圖文一拍即合，他的流體藝術不僅豐富了我詩文的想像空間，並且也添增了詩文的閱讀情趣。

　　在眾多實驗照片中，我努力找尋既能適切表達詩文意涵復具藝術質感的圖像：以似濤浪翻捲又似水花亂濺的迴旋波紋，比擬「讀你的心事密密麻麻、苦苦澀澀、零零亂亂」的情態；以紛紛墜落的無數星點波痕，恰似灰飛煙滅，表達「往事舊夢已然風中灰燼」的悵惘；以平行迴轉的三道線紋，看似星野中的鐵道，映現「人生軌道有多長，思憶的列車就有多遠」的傷懷；以同樣紋理基調的圖像三幅，由淺至深，述說「情繫三生」中「不同的世代，不變的情根，仍有隔世相思，隱隱牽動心腸」的執念。我一再地為那一幅幅光影投射出來的動人圖像而思馳而神迷。有時幾片天光雲影，靜默地叫人沈思；有時微風吹動月下窗幃，幽美地令人嘆息；也有時長簾幕後燈光搖曳，令人欲醉也心碎。當然更多圖像是禪境般地，無法言詮，只能會意。

　　時隔五年，再出版第二本詩集，仍然有幸與王老師合作，但不同的是，拜科技進步之賜，使得這次圖像經過電腦影像處理之後，不但添上色彩多麗，並且還增加排版變化，更富視覺效果，將王老師的流體藝術向前推進一步，直逼當代大師的抽象藝術。透過電腦處理的圖像，在色彩運用成功之外，更清楚地透顯出線條紋理變化的律動美感。線條有時呈直線前進狀況，如平靜流水，看似靜止卻又隱藏動能，富涵「動中有靜，靜中有動」的張力哲理。線條有時又像蔓藤似蜿蜒有致地攀爬在灰色水泥壁上，帶有向陽向上的成長動

The Celestial Rhythm of Nature

More than ten years ago, Dr. Wang, with his special insight, discovered that the flow pictures out of his lab were rich in aesthetic perception, when few faculty and staffs knew about art at the early stage of the university newly established as the institute of technology. He, thus, approached me on the ideas of the flow pictures. With intuitional feeling, I immediately discerned that the beauty of flow resulting from experiment was simply another type of abstract art. The flowing lines and patterns yielded under artificial conditions were so changeable, natural and simple, full of strength, movement and aesthetics to amaze me again and again. Moreover, from a piece by a piece of black and white lines, I saw a piece by a piece of great art in profound meanings and eloquent styles, which depicted not only the murmuring of individual life but also the chanting of universal nature. Such were the celestial beauty beyond the capability of human beings to create. In 1995, I planned to publish the first collection of my poems and considered theses flowing pictures as a perfect match for, on the one hand, enhancing the literary imagination and, the other hand, embellishing the reading interest of my poems.

Among numerous pictures, I tried to pick out those with not only poetic connotation but also artistic feeling as resonance to my poems. Thus, I had had the rotating ripples compared to the mood of "reading the secrets concealed in your mind so closely, bitterly and turbulently" just like rolling waves or splashing water; the innumerable falling sparkles convey the melancholy of "the bygone days nothing but ashes in the wind; the three paralleling lines of railways winding in the wild field reflect the status of "how long the life track is, how much the memory train carries"; the three same- pattern pictures shading from light to dark express "yearning for love remains all the time and touches the heart through life generations." Again and again, I was fascinated by those appealing pictures produced through the projection of the light and shadow: they were sometimes the light and cloud on the sky, so tranquil to make one trance; sometimes drapes fluttering with the wind in the moonlight, so beautiful to make one sigh; and sometimes the candle light flickering behind the long curtain, so bewitching to break one's heart. Yet, there were still more pictures for no words, just like Zen paintings.

In 2000, I intended to publish the second collection of my poems and sought for the cooperation with Dr. Wang again. With the advance of computer technology, this time all pictures could be not only colored but also composed as freely as possible, which added more visual effects to make the flow art simply compare to the abstract masterpieces of contemporary. Through the computing process, the pictures, in addition to good presentation in colors, also shows the aesthetic rhythm of the change of lines distinctly. There were lines sometimes akin to water flowing peacefully with the implied ideas of "movement with stillness; stillness with movement"; sometimes

感；有時也像高粱田或麥田裡的大片禾苗仰望天光雨水的勃發生長之姿。最常見的是山澗急湍，或者是飛下瀑布，奔躍的線條充滿了能量的動感。然而，沒有一種形態比火焰的形態，更能適切地表現出動感，因此更有一種線條以梵谷式的旋渦波紋，表達火焰般地的強烈動感，予人高亢又不安的感覺。每一幅都是自然的巨作。

又五、六個春秋之後，這個流體藝術再度以一種脫胎換骨的不同形式出現，轉換的過程與結果令人驚奇又驚歎。在陰錯陽差的安排下，今年暑假王老師收留了來自重慶大學主修雕刻的交流生－曾華，原只打算借用其藝術專長將流體圖像提昇為精緻的平面藝術，但他卻巧思獨具地把平面藝術轉換為虛擬的雕塑藝術，讓圖像的線條紋理收攝凝鍊在三度空間的各種變形裡，不僅突顯出流體自然紋理的獨特美感，並且呼應著雕塑造形的曲線變化。每一件雕刻作品都風格獨具，可比現代巨作：有亨利摩爾（Henry Moore）式的現代雕塑風格，作品主體或含孔洞或被穿透，且外形曲線起伏，展現空間與實材之間的虛實關係；也有阿爾普（Jean Arp）式的超現實主義風格，以流動的曲線或幾何線，來呈現抽象效果的生物型態，像阿米巴曲線一樣。

十多年來，王老師利用自然流體創造抽象藝術的實驗過程，其實十分類似產生於 1960 年代，以法國瓦沙利(Vassarely)為代表的歐普藝術，它便是利用光線、電磁或水力等機械的精密設計與作用以創造成「動力藝術」（ Kinetic Art ），是一種精心計算的「視覺的藝術」。在發展過程中，王老師的流體藝術也經歷了視覺三部曲：從黑白樸拙的創作初胚，到彩色斑爛的藝術表現，再到虛擬實境的雕塑造形，三個階段各有不同的自然意韻。我愛最初的自然，也愛人工的自然，更愛天人合一的自然，每一種自然都在人為的設計之下，展現不同向度的神奇美妙。隨著條件變化而變化的流體波紋，不只是探索自然的實驗結果，更是宇宙自然透露萬物生命情態的微影。它讓我們窺見了宇宙之心，就是你我的心。因此，自然是最偉大的藝術表現，藝術是最偉大的生命展現。

<div style="text-align:right">

元智大學研發處

簡　婉

二〇〇七年七月

</div>

resembling vines creeping onto the gray wall with the feel of moving upward the sky; sometimes like seedlings of cereal crops growing in the field with the posture of prospering in the sun and rain. The most common were those like swift current in the ravine stream or the waterfall flying down, lines of which were full of galloping energy. However, no lines were more dynamic than those in form of flames, just like Van Gogh's vortex style, expressing the strong movement of blazing which makes one excited and restless. Every one was a masterpiece of nature.

After five years, the art flow again appeared in a completely different form with the changing course and outcome so amazing. When Tseng Hwa, an undergraduate from Chongquing University, came as an intern student under supervision of Dr. Wang in the summer of 2006, he took advantage of his specialization in sculpture to elaborately transform the flow art from plain picture into virtual sculpture, which made line patterns all condensed into the various three-dimensional forms, not only giving the unique aesthetic of natural lines but also responding to the curving changes of sculpture construction. Each has its artistic style in comparison to the works of contemporary masters. They are such as Henry Moore whose works are pierced or containing hollow places or undulating so as to show the relation of abstractness versus concreteness of space and l materials; such as Jean Arp whose works are in his personal style of abstract compositions through an organic morphology, frequently sensuous in form.

The decade-long process of the abstract art evolved by Dr. Wang from his experimental flow is very similar to the mode of Op Art created in 1960s, a work with movement which may be mechanically powered (for example, by electricity, or air or water motion), known as "Kinetic Art". Such kind of visual art is elaborately designed. In the developmental process, Dr. Wang's flow art has also experienced three different visual stages: from the early embryo of black and white pictures, to the brilliant abstract art, and then to the virtual sculptural form, each of which is imbued with natural rhythm. I appreciate different presentations of flow nature, be it simple or complex, all are wonderful in different dimensions. The flow lines, changing with conditions given, are not merely the result of natural exploration but also the revelation of universal nature related to the spirit of the whole creature, from which we come to comprehend that the nature is the great presentation of art and art is that of life.

Office of Research and Development, Yuan Ze Univrsity

Chien, Wan

July 2007

Flow and Art

流體之美
CONTENTS

王立文教授工作室成員

Flow Visualization andArt

王立文教授工作室歷年成員
Professor Wang, Lin-wen Studio's history members

1984	孫大正	莊柏青			
1985	鄭敦仁				
1986	陳燦桐	陳人傑			
1993	李連財	魏仲義			
1994	路志強	呂俊嘉	賴順達		
1995	李慶中	侯光煕			
1996	盧明初	呂逸耕			
1997	鄧榮峰	徐嘉甫			
1998	王伯仁	林政宏	徐俊祥		
1999	粘慶忠				
2000	楊宗達	陳國誌	廖文賢	馮志成	
2001	蔡秀清				
2002	孫中剛	王士榮	鄭偉駿	周熙慧	
2003	龔育諄	莊崇文	林冠宏		
2004	康明方	蘇耕同			
2005	宋思賢	許耿豪	林君翰	劉淑慈	歐陽藍灝　楊玉傑
2006	廖彧偉	許芳晨	郭晉倫	戴延南	楊正安　吳春淵
2007	王順立	黃正男	蘇聖喬	郭順奇	廖炳勳
2008	蔡宏源	黃上華			

王立文　教授　曾華
Professor Wang Lin-wen, Tseng Hwa
曾華　Tseng Hwa
重慶大學　人文藝術學院　研究生
Postgraduate candidate, school of humanity and science, Chongqing University

藝術和科學的相結合是藝術及科學發展的一大趨勢，我們正在努力…

The integration of art and science has emerged as a major trend in the scientific development of geometric art, which is something we are working on ...

流體藝術雕塑化
Transforming
flow art into sculpture

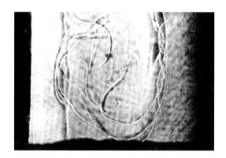

孕

尺寸： 100cm / 100cm / 100cm

材質：不繡鋼鍛造

The Pregnancy

Dimensions: 100cm / 100cm / 100cm

Material: Forged stainless steel

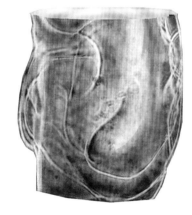

"孕"包含了人世間之大美,一切新生事物的出現,無不經歷一個"孕育"的過程。此作品正是形象化的體現了這一個深刻的涵義。學校是一個育人的地方,是對人生命的再造,是一個孕育人才的地方。

"The Pregnancy" embodies the aesthetics of humanity, the emergence of all things new, all of which are but a birth process. The work depicts tangibly the profound significance of which, in that schools are the hub for nurturing humanity, a recreation of humanity, and a cradle for culminating talents.

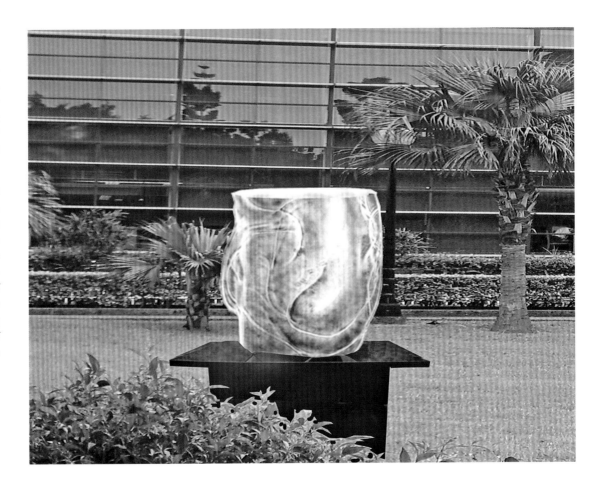

好似一陣微風吹來，撥動著紗窗，和煦的陽光，沐浴著萬物生靈，使人變的疏懶和輕鬆，給人以好心情。

Much like a whistle of gentle breeze caressing sheer fabrics, the balmy sunray bathes all living beings, fostering a carefree ease and harboring an uplift mood.

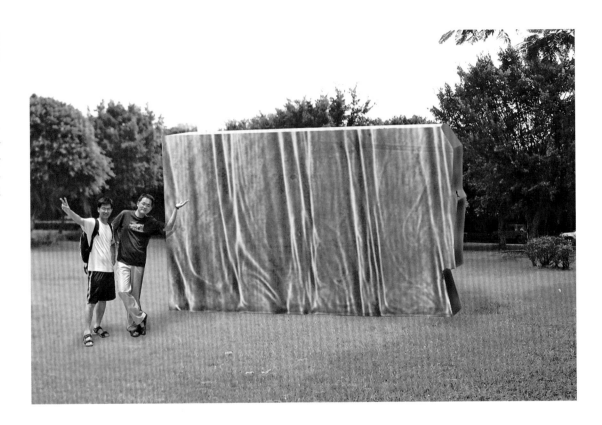

春之舞

尺寸： 200cm / 200cm / 80cm
材質：大理石

The Spring Dance

Dimensions: 200cm / 200cm / 80cm
Material: Marble

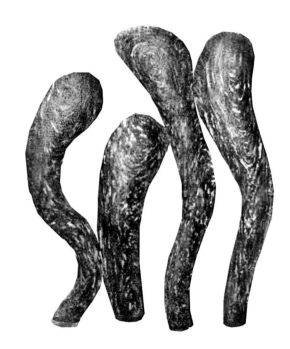

明媚的陽光，跳起歡快
的舞蹈，喻示著春的到
來。

The bedazzling as the sun
bounces to a joyous dance,
suggesting the arrival of the
spring.

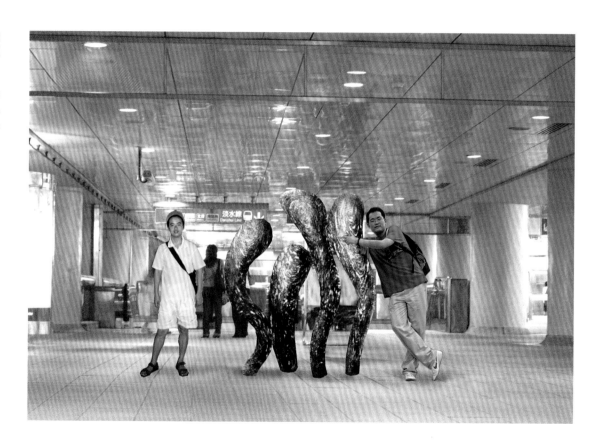

同根相生

尺寸： 200cm / 100cm / 100cm
材質：黑色大理石

Shared Heritage

Dimensions: 200cm / 100cm / 100cm
Material: Black marble

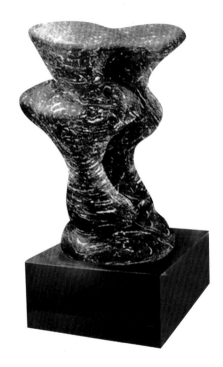

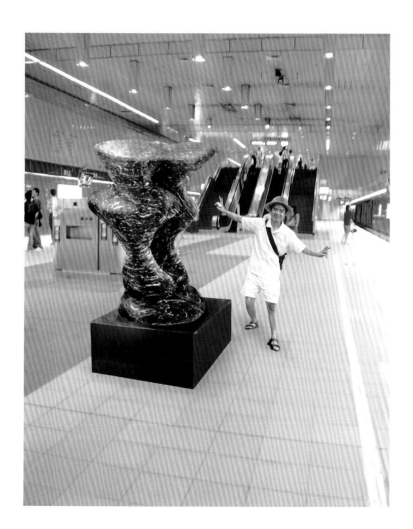

象徵著海峽兩岸骨肉同胞，同根相生，一衣帶水。

Symbolizing that the people across the Taiwan Strait are bound by shared heritage and fate.

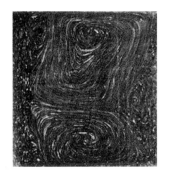

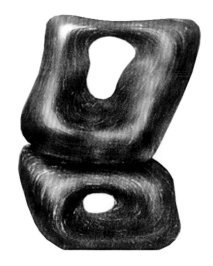

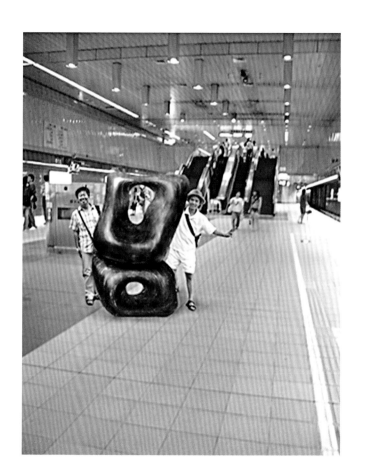

一種亨利‧摩爾式的現代主義抽象雕塑，使人們把更多的眼光投入到雕塑造型本身，享受著雕塑最本真的形體和空間變化帶給人們的愉快心情。

A Henry Moore-inspired modern abstract sculpture, it steers the viewer to focus on the sculpture itself, appreciating the truest form of the sculpture, and the joy that it brings to people for its spatial variation.

春

尺寸： 600cm / 200cm / 200cm

材質：青銅鍛造

The Spring

Dimensions: 600cm / 200cm / 200cm

Material: Forged bronze

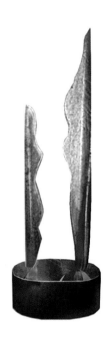

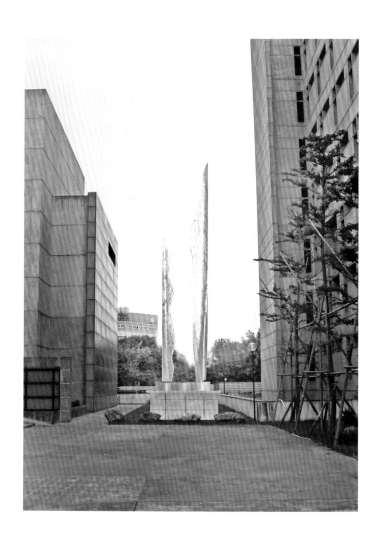

猶如新葉的形象，筆直的挺立著。剛柔並濟的造型，表現出春的生機和活力。為校園帶來點點春意。

The shape resembling new birth stands tall. Its supple yet open configuration depicts the vitality and energy spring bestows, fostering a touch of spring all around the campus.

夢想從這裡起飛

尺寸： 600cm / 300cm / 300cm
材質：黃銅鍛造

Dreams Take Flight Here

Dimensions: 600cm / 300cm / 300cm
Material: Forged copper

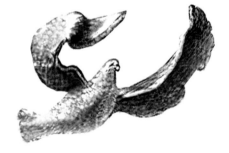

這是夢開始的地方，是我們成長的搖籃。在這裡，我們的羽翼變得更加豐滿。將來有一天，我們會飛向廣闊的藍天，去尋找屬於我們自己的天空。

This is where dreams begin, and a cradle that nurtures us. It is in here that our wings soar. One day, we will take flight to the soaring blue skies in search of a realm of our own.

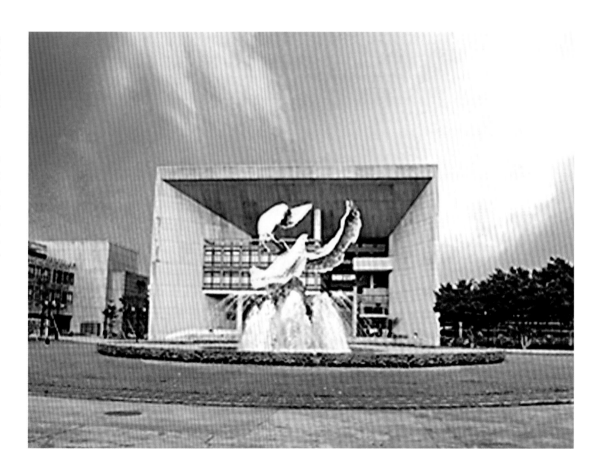

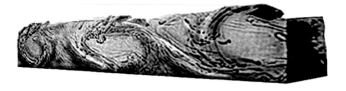

猶如浪花，輕拍著海岸，也猶如一池清水捲起的點點漣漪，純純的愛，為校園增添浪漫氣息。

Like waves awash the shore, and like the passion triggered by ripples in clear water, it adds a touch of romantic ambience to the campus.

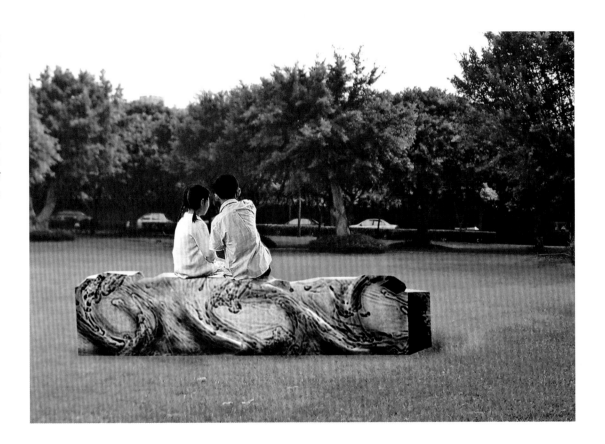

和平鴿的降落，為校園帶來一片寧靜和祥合。具象和意象相結合的手法，使作品更具表現力。願人人都共享和平盛世，體會純真的友誼。

The descent of the peace dove fosters an air of tranquility and serenity to the campus. A technique combining form and abstraction infuses the work with dynamics. May everyone share peace and austerity, and experience the sheer joy of friendship.

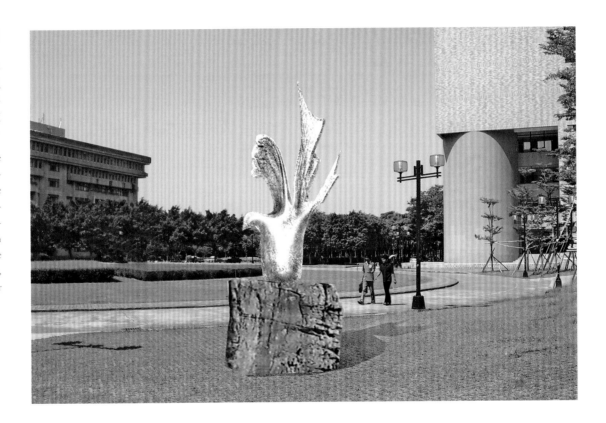

生命之花

尺寸： 500cm / 80cm / 80cm

材質：青銅

The Brilliance of Life

Dimensions: 500cm / 80cm / 80cm

Material: Bronze

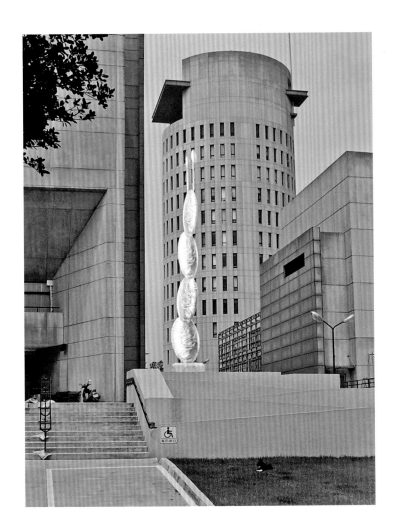

層疊向上的形勢感和花蕾的表現代表了生命的發展狀態和無限的生機。保留原作上的圖案也突顯了生命的人文涵義。作品置於此環境中，也改變原有建築生硬的線條，營造一個生態和人文的環境氛圍。

The upward spiraling form and the manifestation of petals conjure the state of life development and infinite vitality. Preserving the original work's patterns also serves to showcase the intrinsic significance of humanity and life. When placed in the environment, the work not only alters the rigid lines of the building, but also fosters the ambience of ecology and humanity.

科技之光

尺寸： 400cm / 200cm / 200cm
材質：花崗岩

The Luminance of Technology

Dimensions: 400cm / 200cm / 200cm
Material: Granite

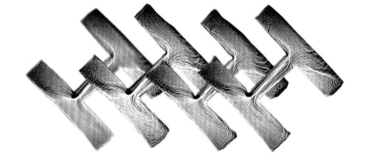

一種純科學的造型，經重新排列，置于環境中，是不是也給人以審美的享受呢？這充分展現了科技和人文的完美融合。

Does not a sheer scientific configuration that has been reconfigured and put in an environment still offer the joy of aesthetics? It is a perfect integration of blending technology and humanity.

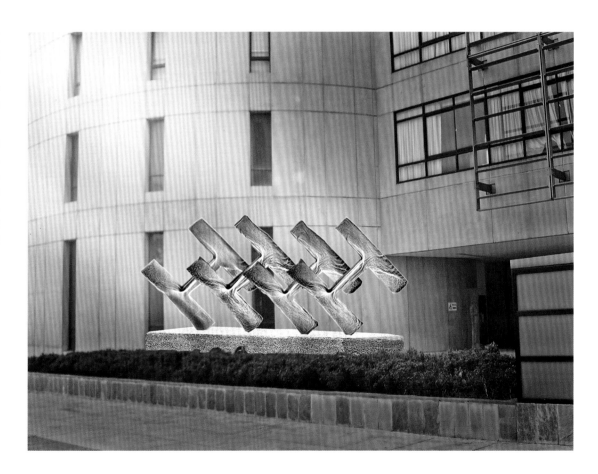

無題

尺寸： 350cm / 300cm / 15cm
材質：鋁合金鑄造

No Name

Dimensions: 350cm / 300cm / 15cm
Material: Cast aluminum alloy

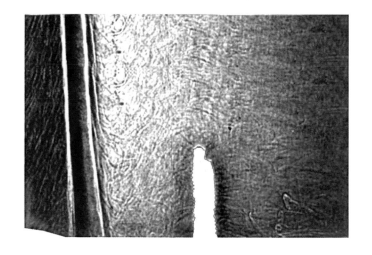

沒有一個準確的主題能夠來概括它。金屬的質感和簡練的形勢使作品極富現代感。小門既是作品美的重要元素，也使作品具有了參與性。這是孩子們和具有童趣的人們休閒的天堂。

No one concept that encompass it. The metal texture and simple form infuse the work with a touch of modernity. The small gateway is more than an important element of the work, but provides the work with a sense of participation. It is a haven of recreation for children and those young at heart.

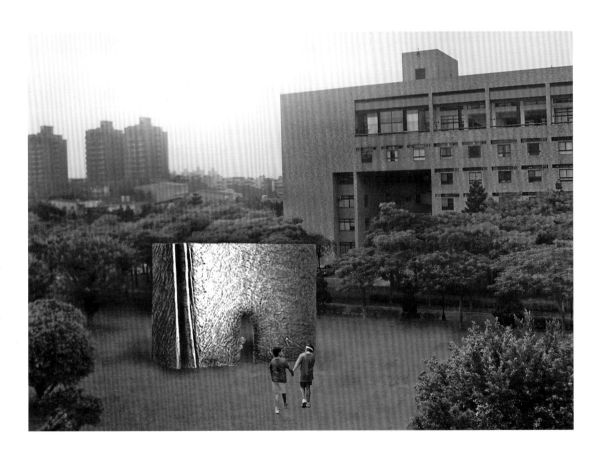

流體柱

尺寸： 250cm / 50cm / 50cm
材質：鋁合金鑄造

Flow Columns

Dimensions: 250cm / 50cm / 50cm
Material: Cast aluminum alloy

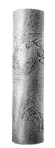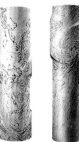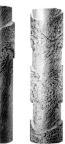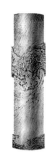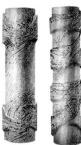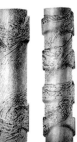

或許你見過形形色色的柱子，但是你見過流體柱嗎？一種試驗所能控制的形勢感，理性中帶著感性。是科學的，但同時也是自然的，放置在環境中或廳堂裡，或許會有不一樣的感受。

Perhaps you have seen a variety of columns, but have your ever seen the flow columns? An experiment-manipulated transcendent feel deemed both rational yet sensual. Scientific and natural, the placement of which in an environment or a hall could perhaps conjure a different perspective.

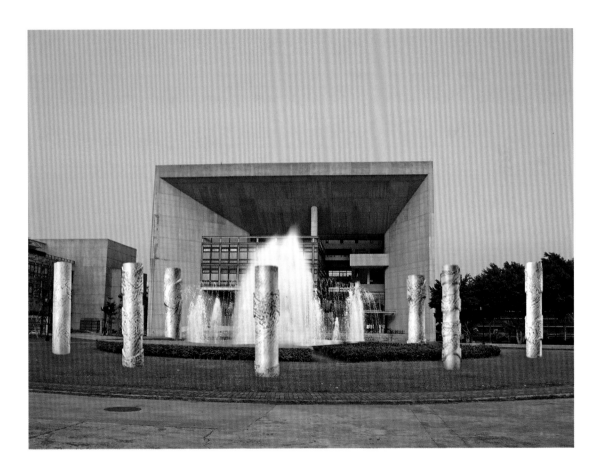

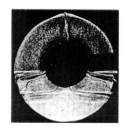

風月

尺寸： 200cm / 200cm / 40cm
材質：雲石

Wind and the Moon

Dimensions: 200cm / 200cm / 40cm
Material: Stone

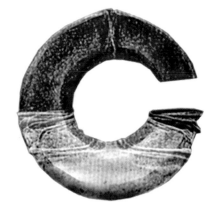

這是科學試驗所做出的
自然美,無需過多的修
飾和更多的語言。猶如
在風吹動中,顯示時間
的流失和歲月的無痕。

A natural aesthetics derived
from scientific experiment
that requires no further
decoration or explanation.
Resembling the flow of
wind and clouds, it con-
jures a constant progress of
time and age.

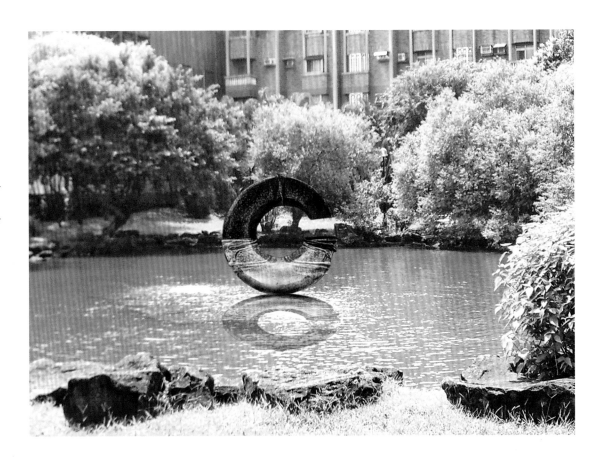

流動的音符

尺寸： 200cm / 80cm / 50cm
材質：不銹鋼鍛造

Flowing Musical Notes

Dimensions: 200cm / 80cm / 50cm
Material: Forged Stainless Steel

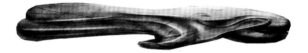

流暢而圓潤的形體，猶如水滴般慢慢散開來，呈現出型體變化的無限可能，有如音符般的線條，展現了流體藝術之流動美。

A smooth, spherical shape dispersing slowly like a drop of water that conjures an infinite possibility of configurable variations, and resembles the line of musical notes that conjures the languid beauty of the flow art.

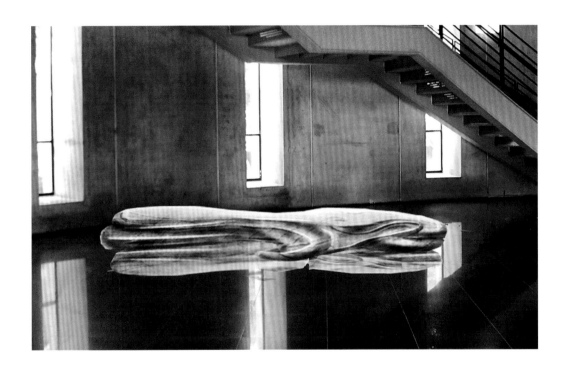

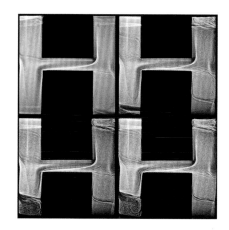

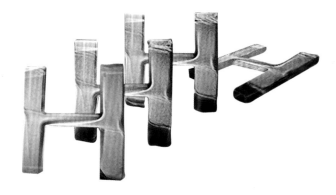

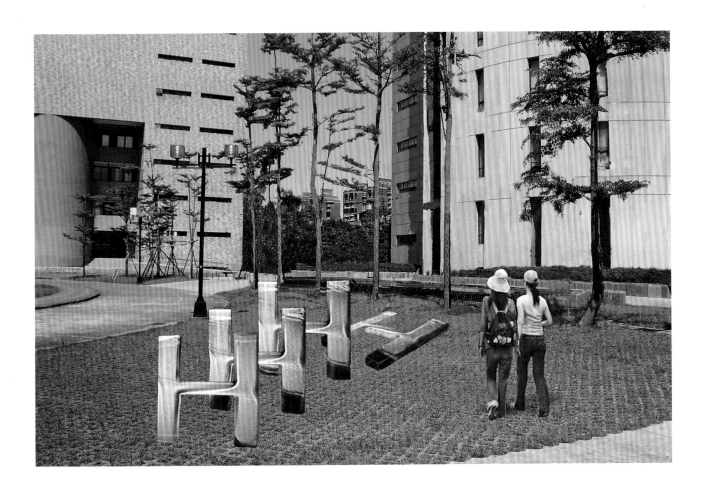

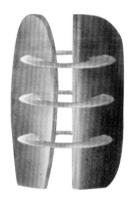

交流　融通

尺寸：500cm / 200cm / 200cm
材質：不銹鋼　黃銅　漢白玉

Exchange, Understanding

Dimensions: 500cm / 200cm / 200cm
Material: Stainless steel, copper, white jadeite

用交流搭起友誼的橋
樑，用融通促進共同發
展。

Exchange bridges friend-
ship, and understanding
fosters mutual develop-
ment.

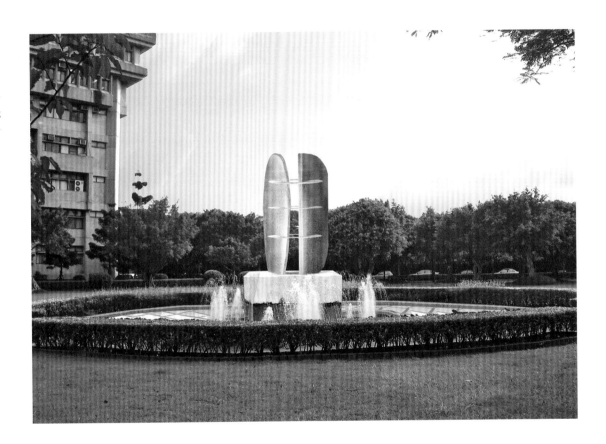

交流者

尺寸： 120cm / 70cm / 30cm
材質：花崗岩

The Exchanger

Dimensions: 120cm / 70cm / 30cm
Material: Granite

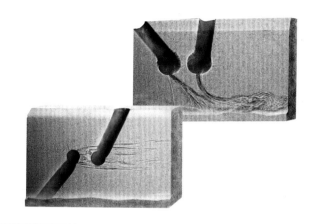

這是三種不同的交流狀態：平和的交流狀態，投緣的交流狀態和激烈的交流狀態。

This represents three different states of exchange: a peaceful state of exchange, a fateful state of exchange, and a heightened state of exchange.

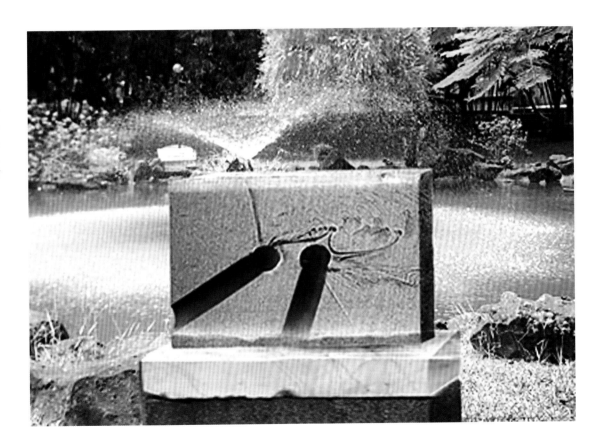

流體科學相片藝術化
Transforming scientific flow photos into art

The objective of this project is to explore the evolving relationship between science and art as illustrated by photographic images of fluid flow. The first portion of the project will focus on techniques that make the physics of fluid flows visible, accompanied by a discussion of the flow physics. Later, the focus will shift to a discussion of how imaging has evolved from both a scientific and artistic perspective.

「二十一世紀人類面臨的最大挑戰，是如何將科學與人文相結合，形成一個統一的文化。三百年前人類犯了一個歷史性錯誤，將人文與科學分開發展，兩者分割越深，人類應付複雜世界的能力就越弱。」

麻省理工學院德托羅斯教授
（Michael L. Dertouzos）

The biggest challenge that confronts mankind in the 21st century lies in how best to integrate science and art to from a unified culture. Three hundred years ago, man made a historic mistake by dividing the development of humanity and science, and the more divided between the two, the weaker mankind's ability would be in responding to the increasingly complex world." Michael L. Dertouzos

The Massachusetts Institute of Technology

王立文 教授 康明方
Professor Wang Lin-wen,
Kang Ming-Fang

康明方 Kang Ming-Fang

元智大學 機械系 碩士
Master, school of mechanical
engineering, Yuan Ze Universtiy

流體科學相片藝術化
Transforming scientific flow photos into art

心經談的六根：眼、耳、鼻、舌、身、意，心有所執，身有所
繫，吾人對美的感受在心境不同的變化，心的感動在於對美的觸
動，而對美的感動又在於心境的放空。當見科學即非科學，見藝
術即非藝術，是名真美………

Of the six roots of the Heart Sutra refers to pertaining to the
determination and perseverance of one's eyes, ears, nose,
body, soul and heart, our perception of aesthetics varies by var-
ied moods, and the sentiment of our hearts is triggered by the
presence of aesthetics, while the sensation of aesthetics rests
on an uncluttered mind. True aesthetics lies in an increasing
blurry divide of science and art.

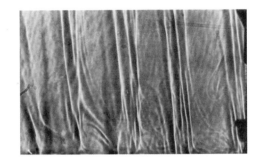

FLOW & AR

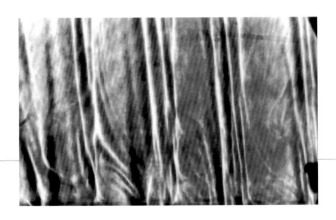

層次

The Layered Perspectives

層次的浪漫線條，恰似希臘女神撩起衣服的皺摺，如紡紗般飄逸而柔軟，幽幽的訴盡千古年的美麗與哀愁。

The layered romantic lines, resembling the fabric pleats found on a Greek goddess, conjures a flowing suppleness retelling the beauty and sorrow of the thousands of years gone by.

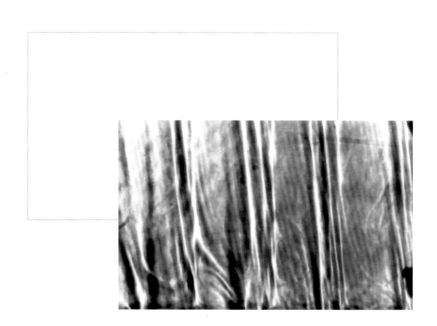

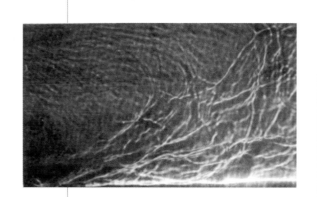

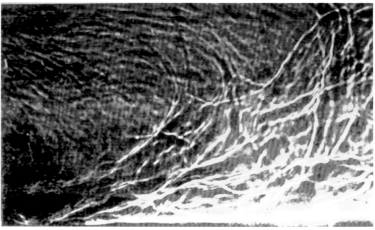

FLOW & AR

絢麗
The Majestic Brilliance

靈魂如奔放烈火般在皮膚下炙熱燃燒，源源不絕熱情舞動
著，表達出內心無限的活力與希望。

Like soul burning hot under the skin like wildfire, and
shimmering with plenty of passion, it conjures the infinite
vitality and hopes from within the heart.

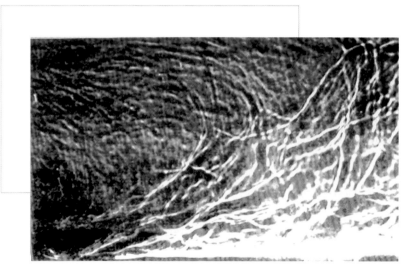

FLOW & AR

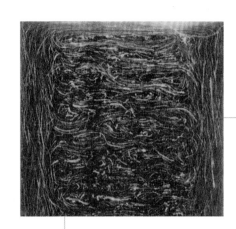

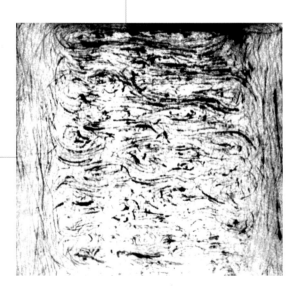

LOW & ART

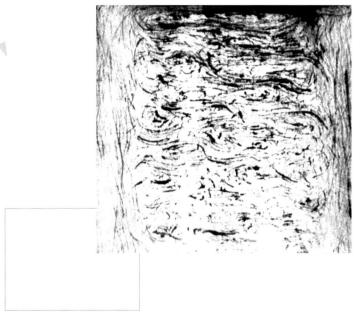

混沌
The Chaos

貌似隨機的構圖，卻又隱藏著秩序。以冷色調表達雜亂線
條中的寧靜與深沉。

It appears to be in a random conception, yet hidden with
a sense of order. A cool tone has been deployed to proj-
ect the tranquility and calm amid the chaotic lines.

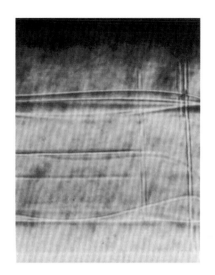

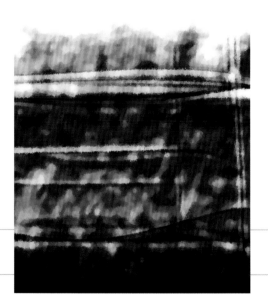

FLOW & AR

水的線條
The Waterlines

簡單似波浪形之線條，切割出和平、寧靜，產生令人了然於心的美感。

The simplistic wave-like lines chisel out peace and tranquility, harboring a sense of aesthetics only perceptible to the heart.

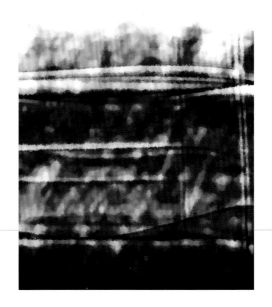

FLOW & AR

LOW & ART

生命的脈動
The Pulsation of Life

交錯縱橫的抽象線條，恰似生靈彼此交流的脈絡，在艱困
環境中展現生命的活力與韌性。

The interwoven abstract lines, resembling the pulse of
mutual soul exchange, conjure the vitality and endurance
of life under difficult circumstances.

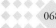

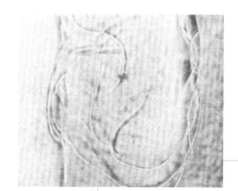

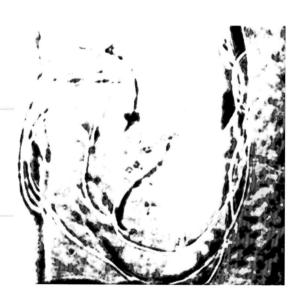

FLOW & AR

孕

The Pregnancy

以溫暖、熱情的紅色，表現出孕育過程偉大無私與迎接新生的喜悅。

The warm, passionate red hue is used to project the grand, unselfish birth process, and the joy of greeting the newborn.

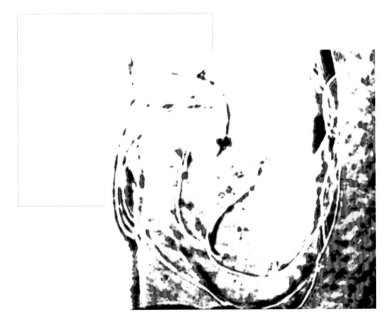

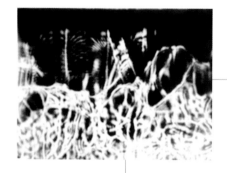

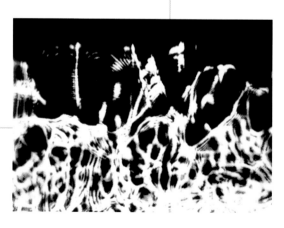

FLOW & AR

LOW & ART

戰爭進行曲
The Wartime March

奔放的抽象風格，敘述著無情戰場上緊張氣氛與生死存亡
的張力。

A titillating abstract form tells of the tense atmosphere in
unrelenting battlefields and the wrangling between life
and death.

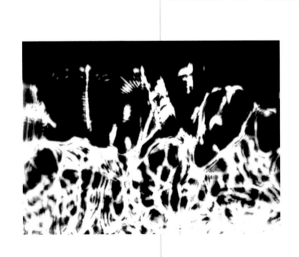

FLOW & AR

FLOW & ART

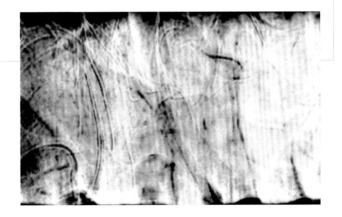

憶

The Memories

自然樸拙的風格，簡單有力的線條，如岩畫般，發人思古之幽情。

A natural, rustic style that simple yet dynamic lines conjures up the nostalgia resembling rock paintings.

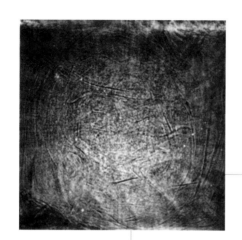

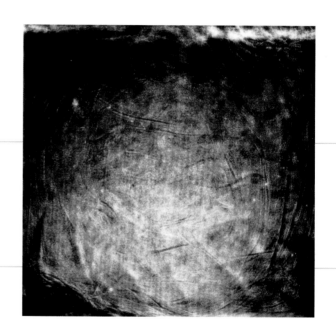

FLOW & AR

迷惘

The Inscrutability

前生、今世，穿梭在夢的無限輪迴。

The past life and the present life are interwoven in the dreams of what seems an endless cycle of reincarnation.

LOW & ART

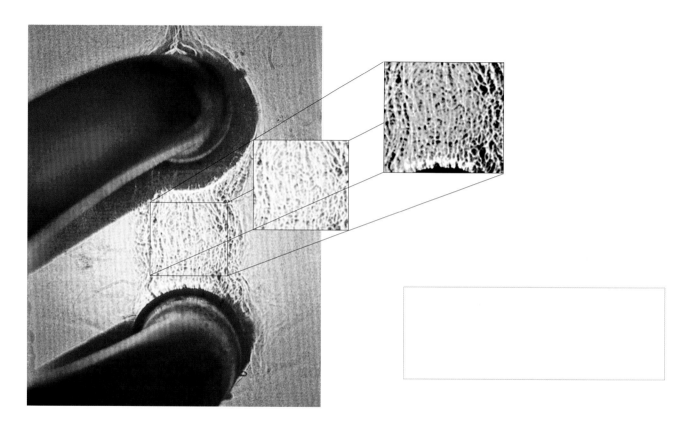

FLOW & AR

LOW & ART

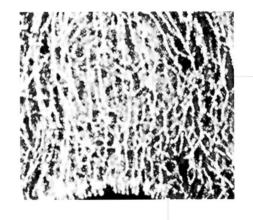

交錯
The Interlacing

交錯的線條有雜亂的視覺感，象徵現實與未來，真實與虛幻相交。

The interlacing lines conjure a chaotic visualization, symbolizing the interaction of reality and the future, reality and mirage.

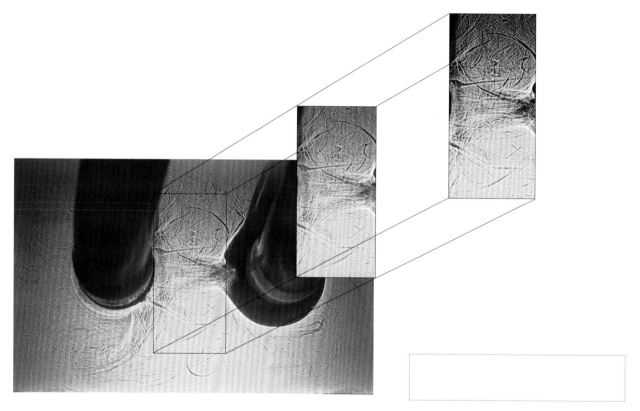

FLOW & AR

豐收
The Harvest

浪花濤盡煙波浩淼，流暢的曲線，描繪水上人家漁獲的豐
收及大自然的生生不息。

In an immense misty span of choppy waves, the smooth
curvature lines depict the water-dwellers' harvests, and
nature's sustenance.

FLOW & AR

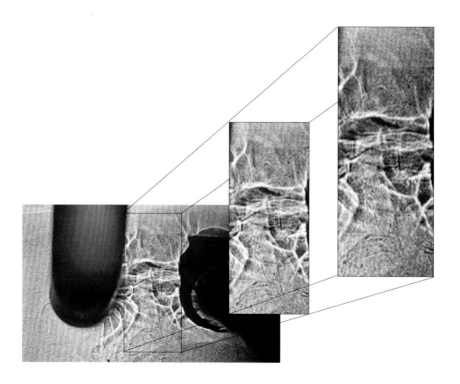

LOW & ART

冬之樂
The Winter Joy

早晨陽光初現，寧靜孤獨演奏出一天的序曲。

At the peek of the morning sun, the tranquil serenity strikes a prelude as the day unfolds.

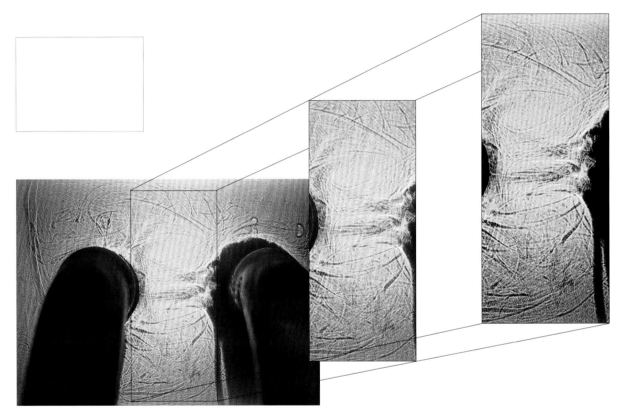

FLOW & AR

無限
The Infinity

恰似一幅潑墨山水畫，給予人一種有限的時空，於畫外做
無限的延續，散發濃濃的禪意。

Resembling a splash painting, it conjures an infinite time
and space, extending beyond the painting and projects
the spirituality of a Zen ambience.

LOW & ART

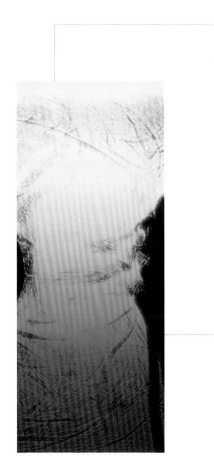

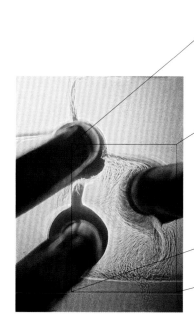
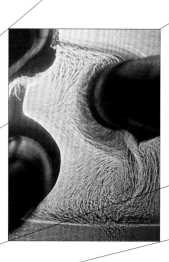
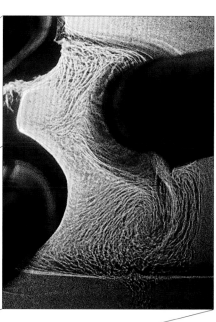

FLOW & AR

童話世界
The Child's World

在心中是否也曾經有一個充滿奇異的理想世界，隨著時間的增長，不得不適應世俗，漸漸忘卻了那在童年裡的夢遊仙境。

Have you ever thought of an amazing fantasy world? As time progresses, one trades worldliness in response to the mortal world but has inadvertently forgotten the unadulterated wonderland of one's childhood.

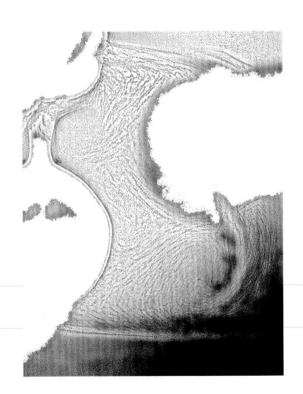

LOW & ART

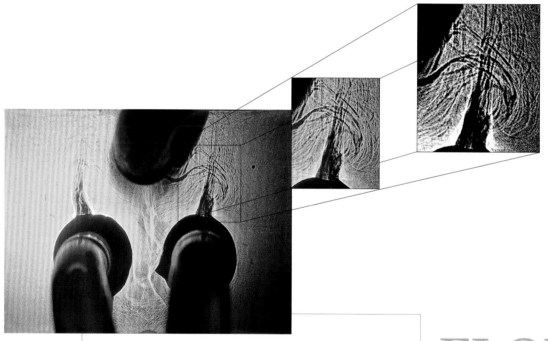

FLOW & AR

LOW & ART

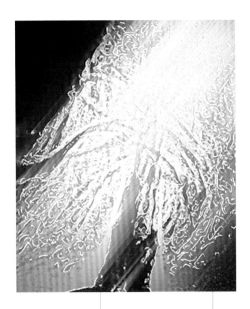

蒼勁
The Firm Resolve

非具像恣意揮動的線條勾勒出樹的樣貌，於初春的時節，
老樹發新芽，陽光灑下充滿活力的生機及蒼勁的孤傲。

With obscured and random lines framing a hanging con-
figuration, new shoots being budding on old trees in the
early spring, basking under the sun with vibrant energy
and a touch of firm resolve.

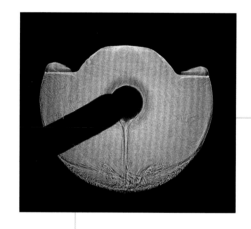

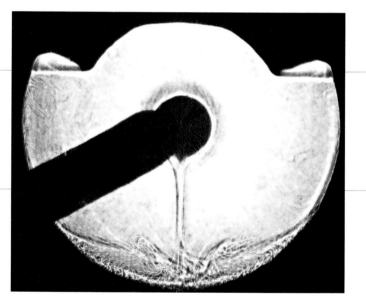

FLOW & AR

衝擊
The Impact

面對著矛盾。好與壞並存，心靈與物質的矛盾於潛意識中衝擊著。

When faced with ambiguity and the coexistence of good and bad, the dilemma of spirituality and materialism impacts one's subconsciousness.

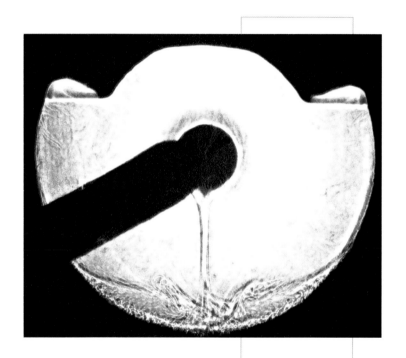

FLOW & AR

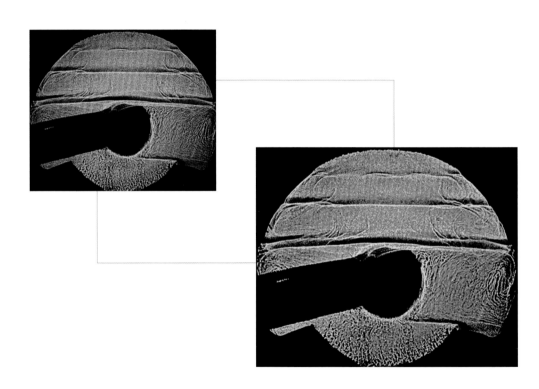

天堂
The Heaven

人間樂園。代表人們對自然、喜樂 與平和的嚮往。

A utopian bespeaks of mankind's longing for nature, joy and peace.

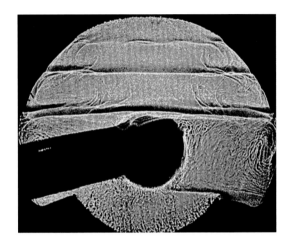

LOW & ART

FLOW & AR

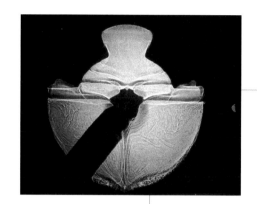

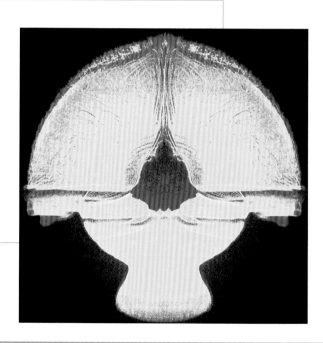

LOW & ART

對自然的禮讚
The Homage to Nature

如火山爆發般，一股蓄勢待發的力量，充滿自然令人讚嘆
豐沛的生命力，一種野性的美。

An emerging dynamic power, like a volcanic eruption,
beckons a natural and all-encompassing vitality, and a
rustic form of beauty.

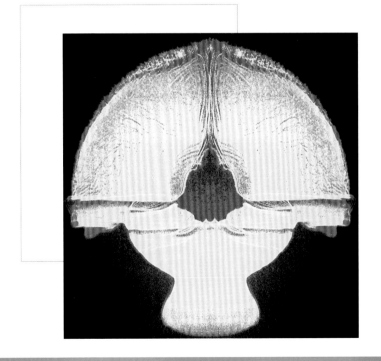

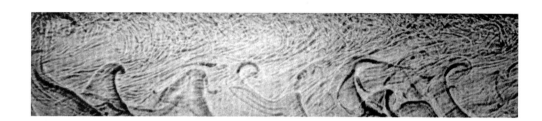

FLOW & AR

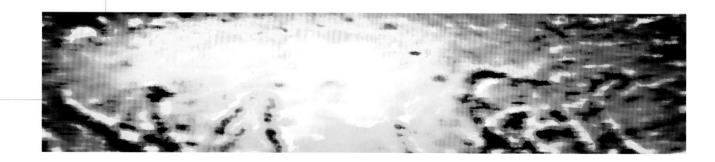

秋天草原上的一陣狂風
The Sudden Gust Sweeping across the Autumnal Plane

風呼嘯無情吹動著芒草，捲動的草原驚叫著。

As unrelenting wind batters the reeds, the rolling grass plane is sent to roar.

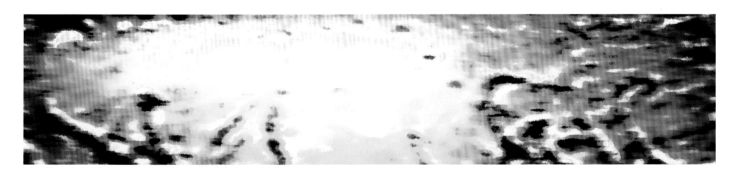

FLOW & AR

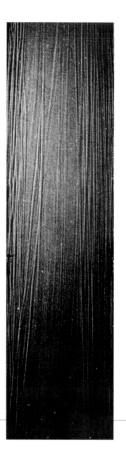

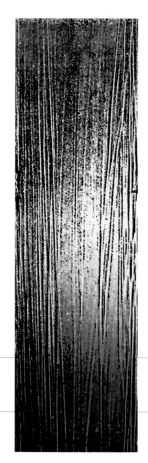

LOW & ART

線條的構圖
The Linear Conception

疏密相間的單純線條，交錯迸出明快的節奏。

The intermittently configured lines interweave to concoct a brisk rhythm.

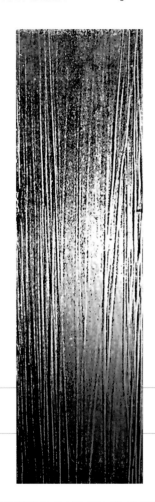

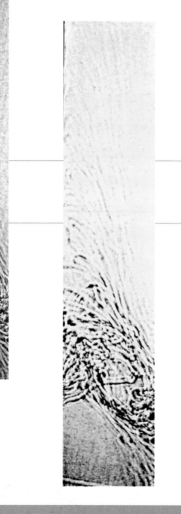

FLOW & AR

LOW & ART

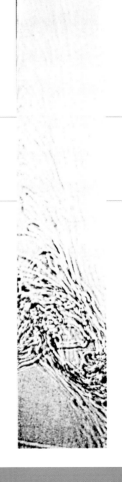

前進眞理
The Progress of Truth

橫溢奔放的線條律動，象徵大學之道對於真理追求的生生
不息。

The abundant, untamed linear rhythm conjures a perse-
verant doctrine for the pursuit of truth.

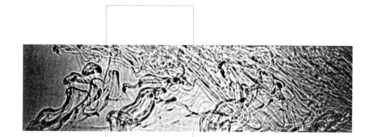

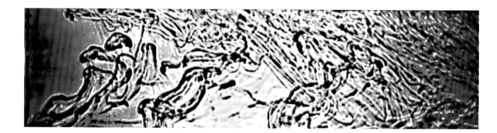

FLOW & AR

叢林競技場

The Jungle Arena

獵人追趕著獵物，獵物因狂奔而扭曲形體，奔向通往存活的方向。獵人與動物有共同的目標─生命的延續。

As hunters chase the prey, the prey contorts its shape in a stampede, running towards the direction of survival, where the hunter and the animals share a common faith — the continuity of life.

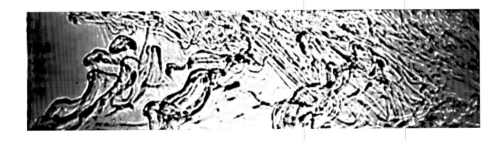

LOW & ART

FLOW & AR

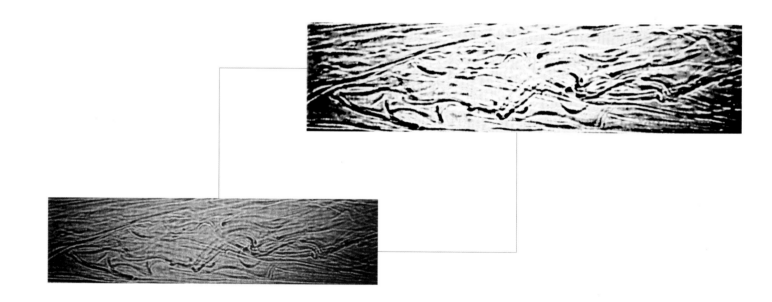

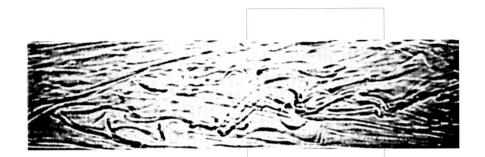

律動

The Rhythm

以線條表現符號性、抽象化，展現音樂的律動，顯得活潑有生氣。

Lines projecting symbolism and abstraction are deployed to depict the rhythmic movement of music, harboring a sense of liveliness and agility.

LOW & ART

FLOW & AR

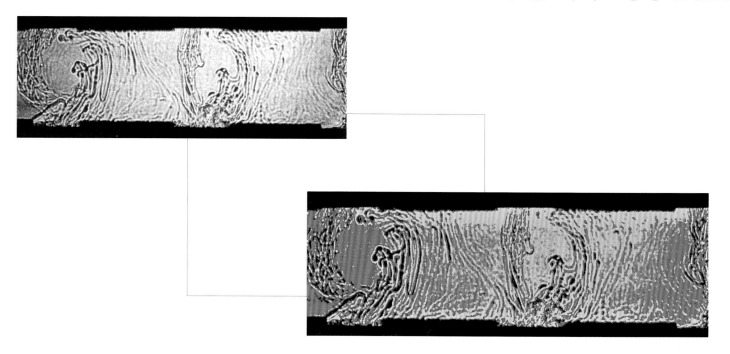

舞動
The Dance Movement

三位舞者翩翩起舞，優雅浪漫的舞出生命之歌。

The three dancers strike a dance of elegance and
romance in praise of life.

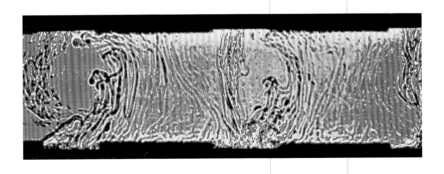

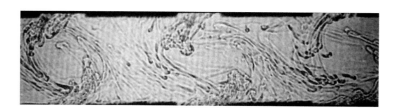

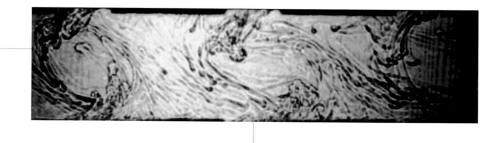

FLOW & AR

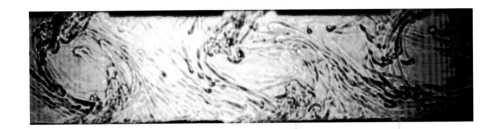

奔騰年代
The Soaring Era

粗獷、明快線條揮灑，造成緊張、神秘的氣氛與節奏感，
時代巨輪快速向前奔騰、轉動著。

Bold yet swift lines are deployed to construct tension and
a mysterious ambience and rhythm, as the wheel of time
rotates and progresses unrelentingly.

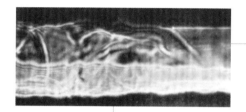

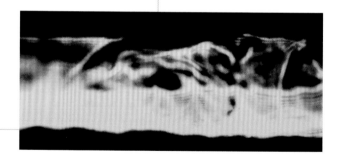

FLOW & AR

FLOW & ART

夢河
The Dream River

如影像膠捲般可快轉、定格與倒帶，蜿蜒流長，似快似慢，不知流向何方，潛意識中的夢河。

Like the cellophane film that can be rotated fast forward, stop or reserve, the winding stream that seems fast yet slow flows toward somewhere unknown, a dream river in one's subconsciousness.

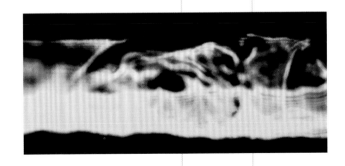

FLOW & AR

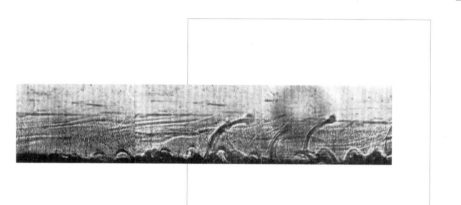

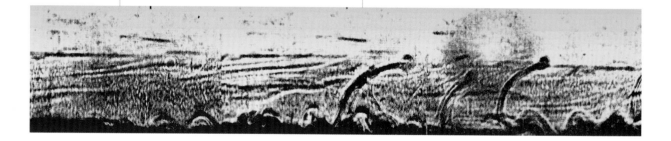

莊稼收成後
The Post Crop Harvesting

豐收的季節，喜悅中有祥和。

In the harvest season, there is joy accompanied by harmony.

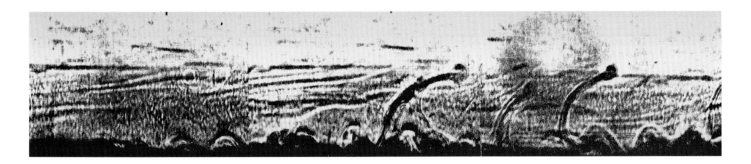

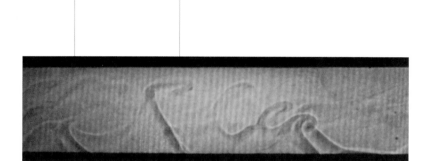

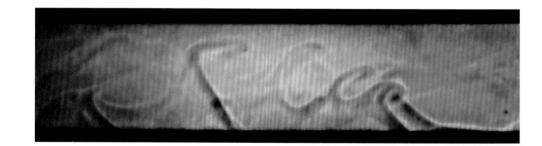

FLOW & AR

LOW & ART

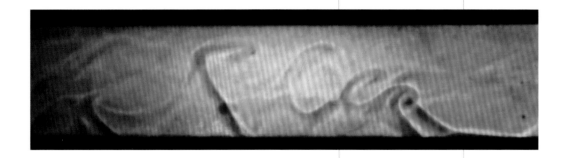

律動的紋理
The Rhythmic Pattern

簡約的線條，如音律般波動的美感，明亮而輕快。

The simplistic lines conjure a rhythmic flow of aesthetics
that is both luminous and upbeat.

FLOW & AR

激起
The Agitation

隨性的線條跳動，恰似船於水面激起的波動，長且平滑，
勾勒出平和輕鬆的心情。

The movement of random lines, mirroring ripples on the
water surface, running smooth and long conjure a peace-
ful and delightful mood.

FLOW & AR

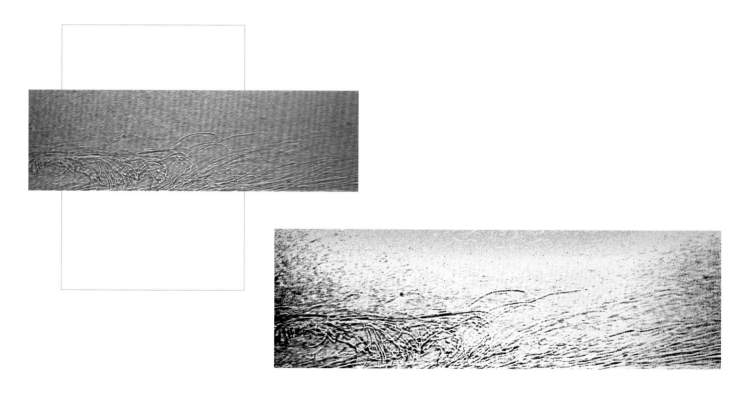

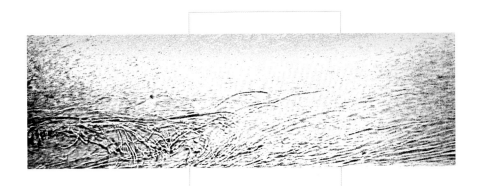

緊張的節奏
The Tension Bound

明亮顏色的構圖，搭配著快速流動的線條，如同競技場上
緊張的節奏。

A brightly colored layout, accompanied by rapidly flowing
lines, bespeaks of the tension-bound mood at an arena.

FLOW & ART

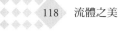

FLOW & AR

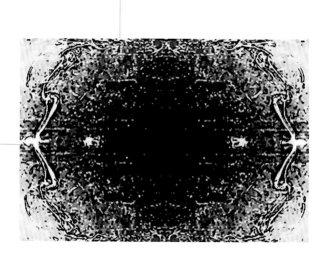

FLOW & ART

向太陽致敬
The Salutation to the Sun

經由四張相同圖案構成一幅向日葵圖形，挺起身軀望著炎熱的太陽，象徵對熱情的感動。

With four identical patterns making up a sunflower pattern, it symbolizes a moving passion as one lifts the torso to embrace the burning sun.

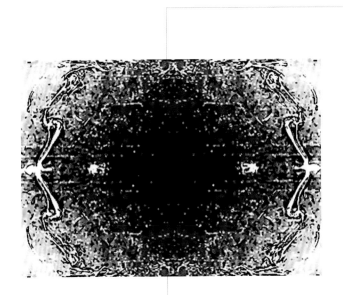

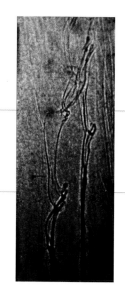

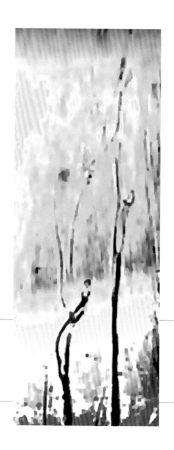

FLOW & AR

FLOW & ART

樸

The Rustic Simplicity

鉛華洗盡，今非昔比，原來變化中有永恆。

Down with the finery, and gone are yesteryears, there is eternity in metamorphosis after all.

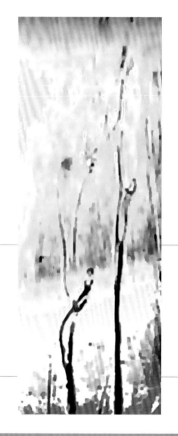

FLOW & AR

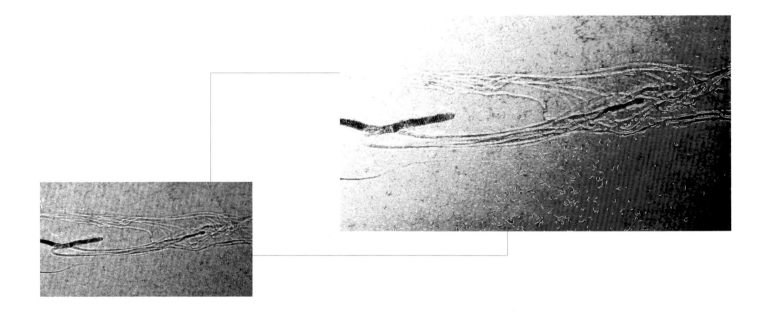

天空
The Sky

明亮的色調，寧靜的天空，無限空間與生命
的延續。

A vibrant tone of colors, the tranquility of
the sky projects an infinite space and the
continuity of life.

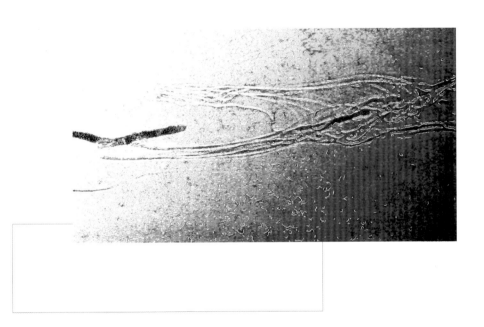

FLOW & ART

FLOW & AR

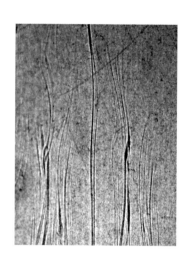

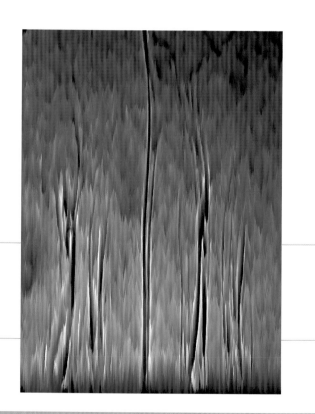

瞬間

The Momentary Instant

動態的線條，代表時間快速流逝，像風一般輕輕的滑過身邊，卻劃出永恆。

What seem moving lines come to project the rapid progression of time sweeping by like a breeze but leaving behind an eternity.

FLOW & ART

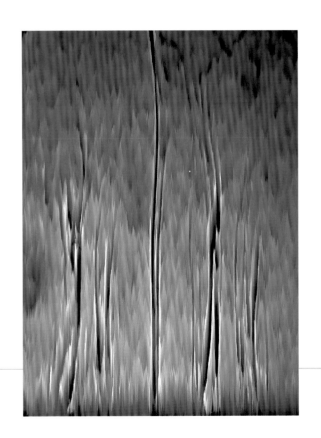

FLOW & AR

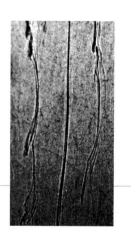

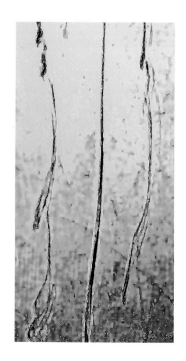

繁華盡落
The Down Trodden

繁華盡落，浮生若夢，往事只能追憶。

Down with the finery, the fleeting existence could only be
captured in distant memories.

LOW & ART

體之美

作　　　者／王立文、曾華、康明方

倡 印 者／元智大學

著作財產權人／王立文教授流體藝術工作室

出 版 者／揚智文化事業股份有限公司

發 行 人／葉忠賢

登 記 證／局版北市業字第 1117 號

地　　　址／台北縣深坑鄉北深路三段 260 號 8 樓

電　　　話／(02)2664-7780

傳　　　真／(02)2664-7633

E-mail ／ service@ycrc.com.tw

印　　　刷／鼎易印刷事業股份有限公司

ISBN ／ 978-957-818-830-3

初版一刷／ 2006 年 12 月

二版一刷／ 2007 年 9 月

定　　　價／新台幣 350 元

本書如有缺頁、破損、裝訂錯誤，請寄回更換

國家圖書館出版品預行編目資料

流體之美 ＝Flow and art／ 王立文，曾華，康
明方合著. -- 二版. -- 臺北縣深坑鄉：揚
智文化, 2007.08
　　面；　公分.
中英對照
ISBN 978-957-818-830-3(精裝)

1.高科技藝術 2.美學 3.流體力學

901　　　　　　　　　　　　96014294